the world's a mom

the world's a

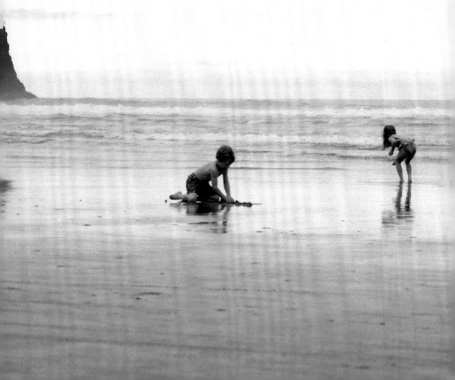

mom

Jackie Alpers

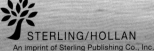

STERLING/HOLLAN
An imprint of Sterling Publishing Co., Inc.

New York / London
www.sterlingpublishing.com

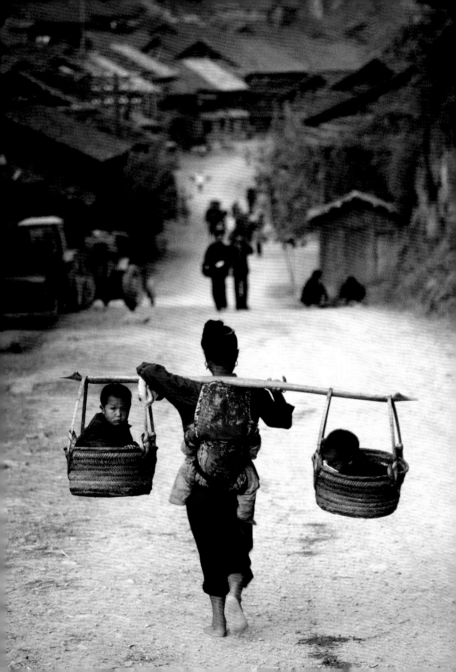

Mothers are all around us: in the grocery store, at the mall, strolling along sidewalks, driving to work. Sometimes they're so prevalent that we forget just how precious they truly are. Without their self-less love and affection, we could not thrive. Without their constant strength and encouragement, we could not succeed. Without their show of patience, wisdom, and understanding, we could not grow up to be wonderful parents ourselves.

Only when we stop to think back on our mother's role in our life do we realize how many wonderful gifts she gave us along the way. But what would she see if she looked back? Probably something similar to the images in this book: a series of tiny, infinitely magical moments that define her long and rewarding journey as a parent.

This book is a photographic reflection on the greatest wonder of the world: that unbreakable bond between mother and child. It exists in surprising ways in the animal kingdom and it flourishes all over the globe. While we may try to express in words how deeply we care about our mothers, sometimes a picture says it with more simplicity and grace.

This book is a tribute to all the mothers in the world, because their love makes it a better and brighter place in which to live.

Mothers are instinctive philosophers.

Harriet Beecher Stowe

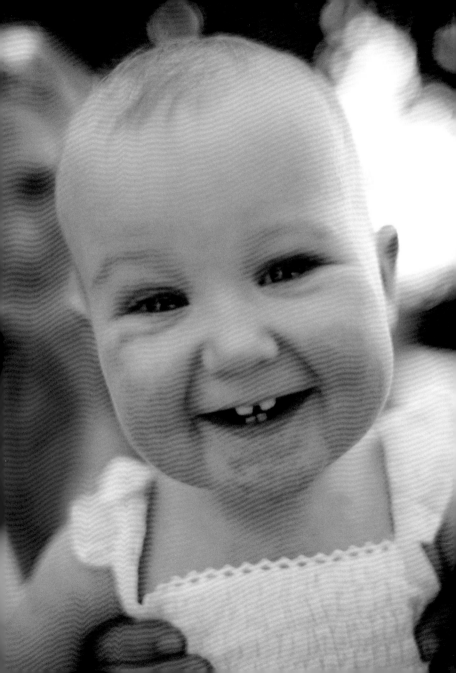

A mother is the truest friend we have, when trials, heavy and sudden, fall upon us; when adversity takes the place of prosperity; when friends who rejoice with us in our sunshine, desert us when troubles thicken around us, still will she cling to us, and endeavor by her kind precepts and counsels to dissipate the clouds of darkness, and cause peace to return to our hearts.

Washington Irving

Being deeply loved by someone
gives you strength;
loving someone deeply
gives you courage.

Lao Tzu

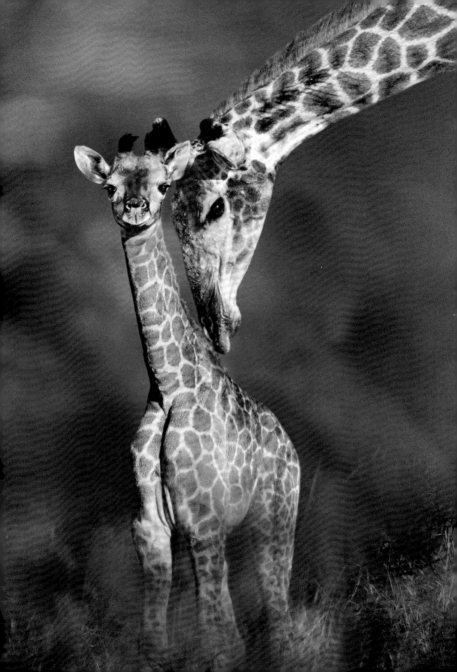

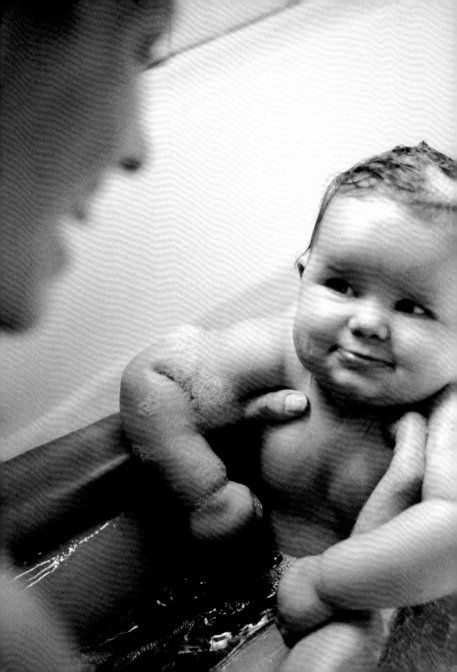

A mother understands
what a child does not say.

Jewish Proverb

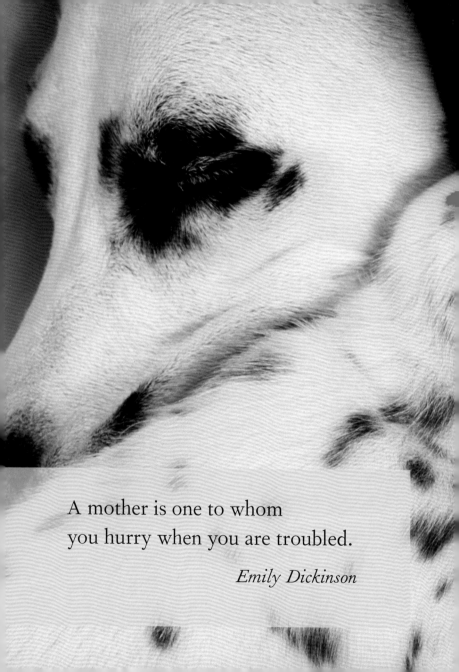

A mother is one to whom
you hurry when you are troubled.

Emily Dickinson

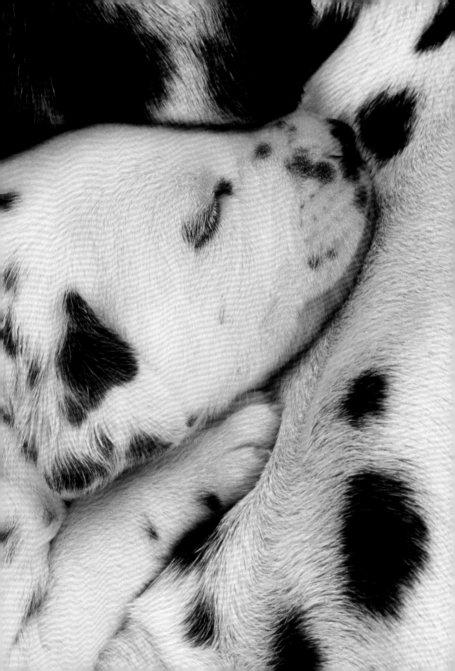

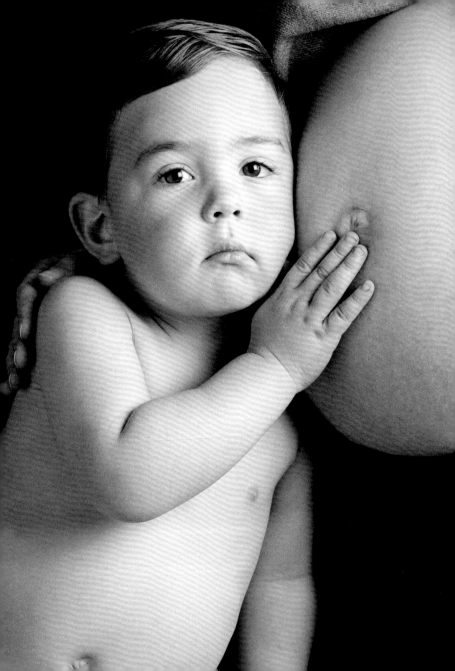

To a child's ear,
"mother" is magic in any language.

Arlene Benedict

I hope they're still making women like my momma. She always told me to do the right thing. She always told me to have pride in myself; she said a good name is better than money.

Joe Louis

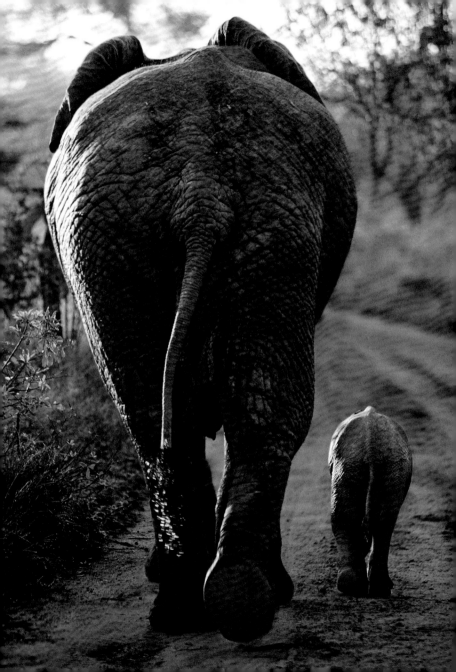

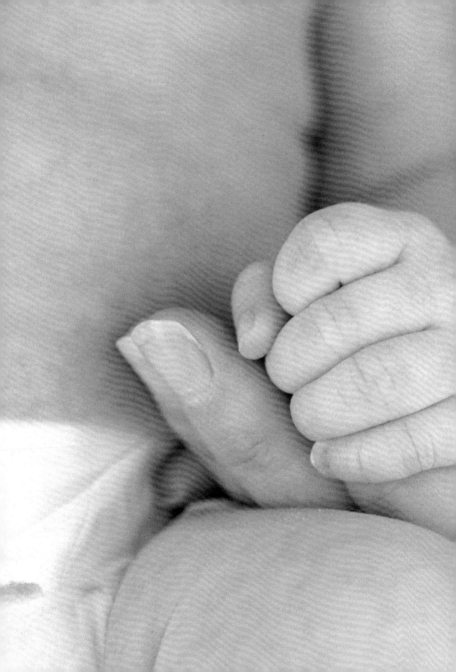

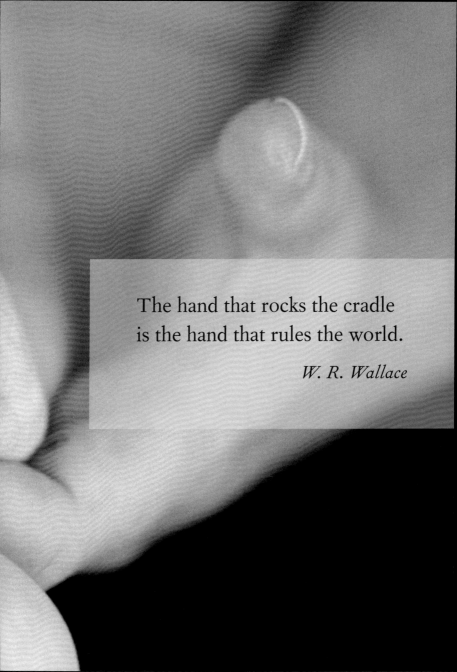

The hand that rocks the cradle
is the hand that rules the world.

W. R. Wallace

At work, you think of the children you have left at home. At home, you think of the work you've left unfinished. Such a struggle is unleashed within yourself. Your heart is rent.

Golda Meir

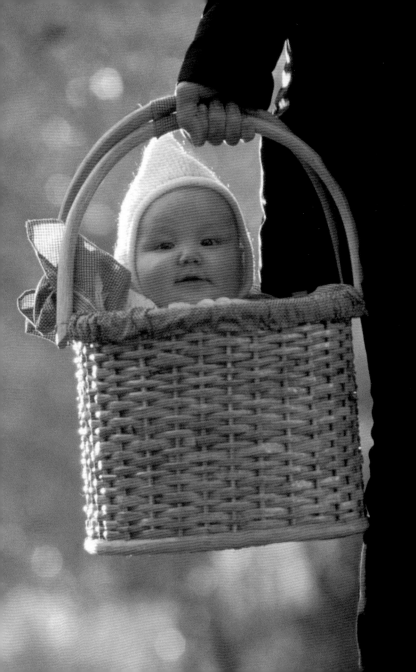

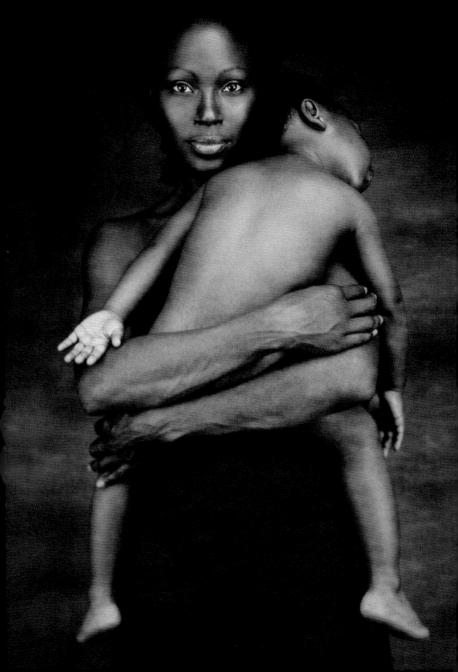

Who ran to help me when I fell,
And would some pretty story tell,
Or kiss the place to make it well?
My Mother.

Anne Taylor

Sometimes the strength of motherhood
is greater than natural laws.

Barbara Kingsolver

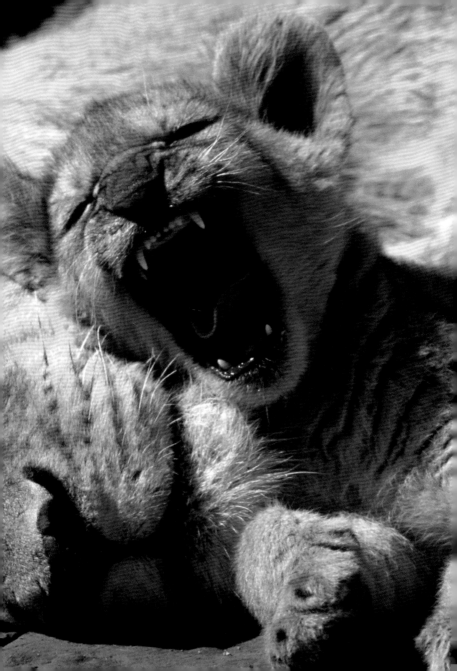

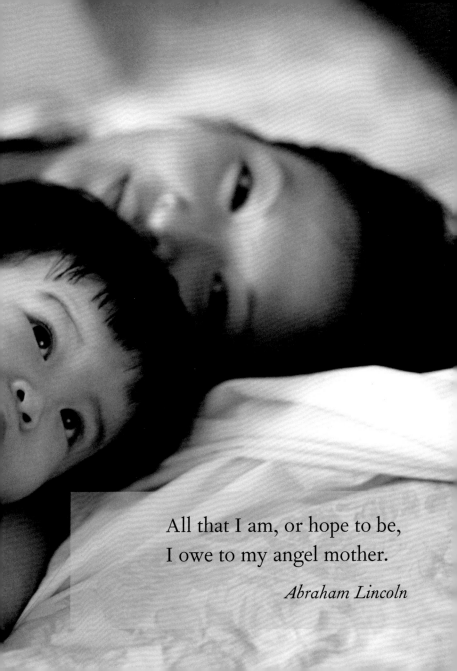

All that I am, or hope to be,
I owe to my angel mother.

Abraham Lincoln

Don't judge each day by the harvest you reap, but by the seeds you plant.

Robert Louis Stevenson

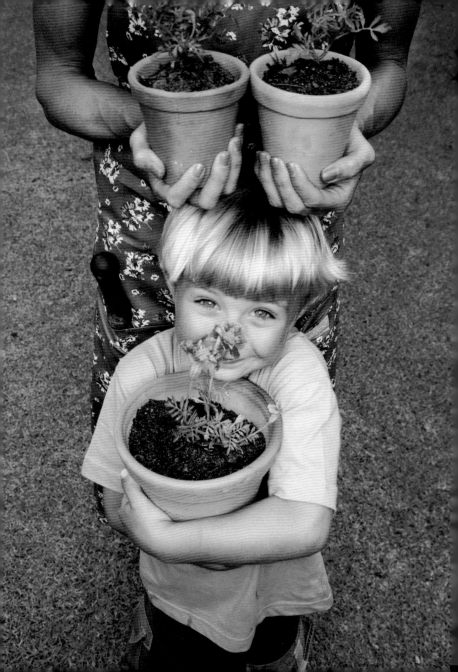

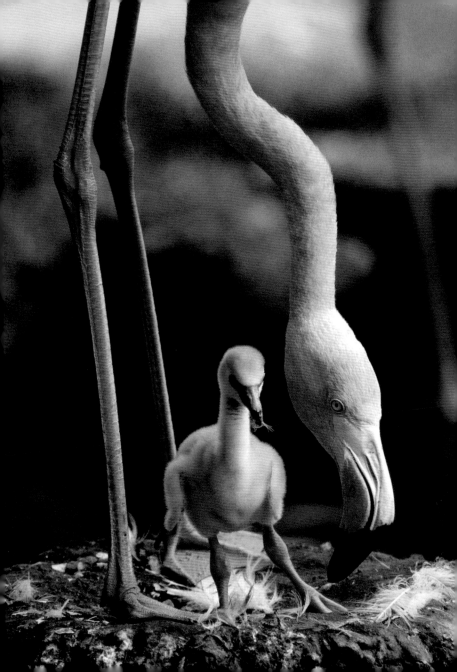

There are two lasting bequests we can give our children. One is roots. The other is wings.

Hodding Carter, Jr.

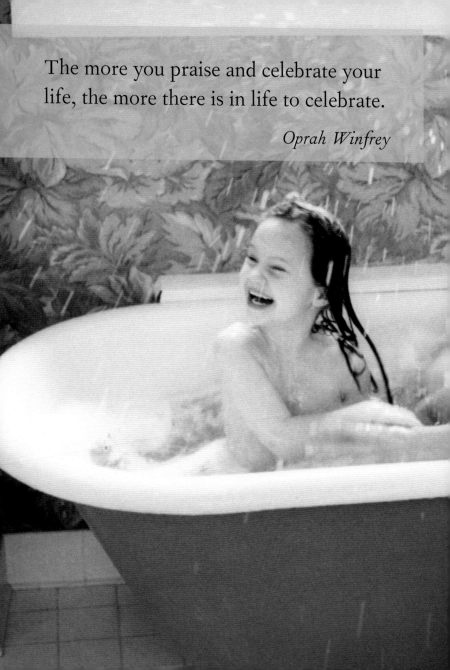

The more you praise and celebrate your life, the more there is in life to celebrate.

Oprah Winfrey

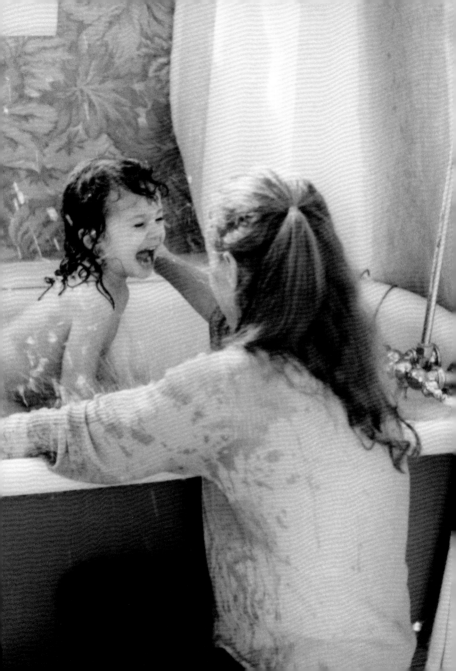

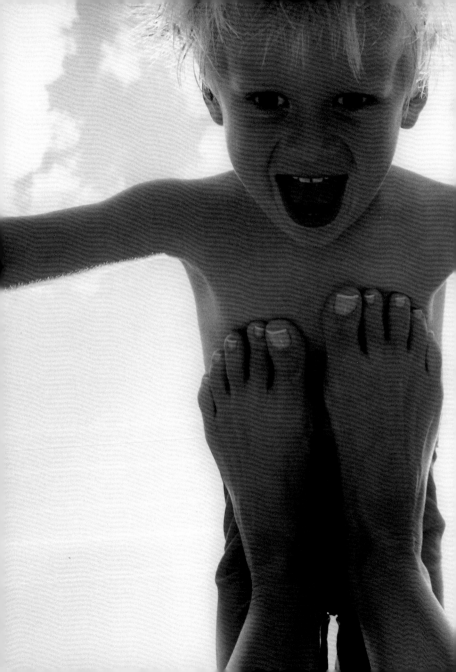

My mother said to me,
"If you become a soldier,
you'll be a general;
if you become a monk,
you'll end up as the pope."
Instead, I became a painter
and wound up as Picasso.

Pablo Picasso

The only way to live is
to accept each minute
as an unrepeatable miracle,
which is exactly what it is:
a miracle and unrepeatable.

Storm Jameson

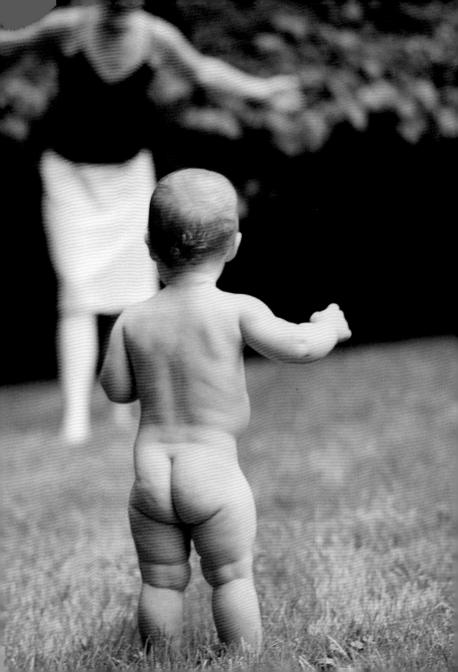

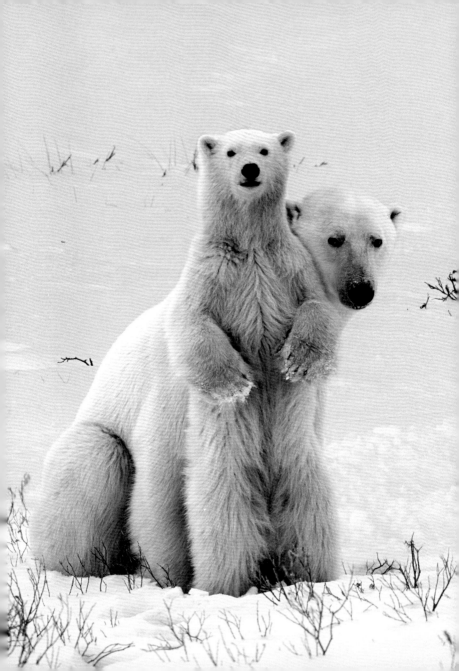

Becoming a mother makes you the mother
of all children. From now on each wounded,
abandoned, frightened child is yours.
You live in the suffering mothers of every
race and creed and weep with them.
You long to comfort all who are desolate.

Charlotte Gray

No animal is so inexhaustible as an excited infant.

Amy Leslie

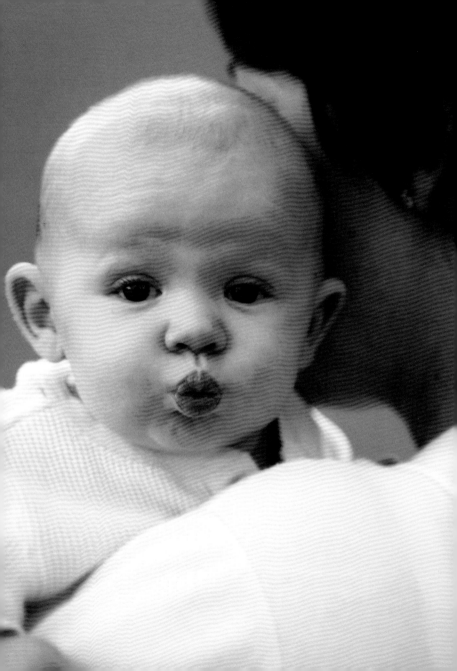

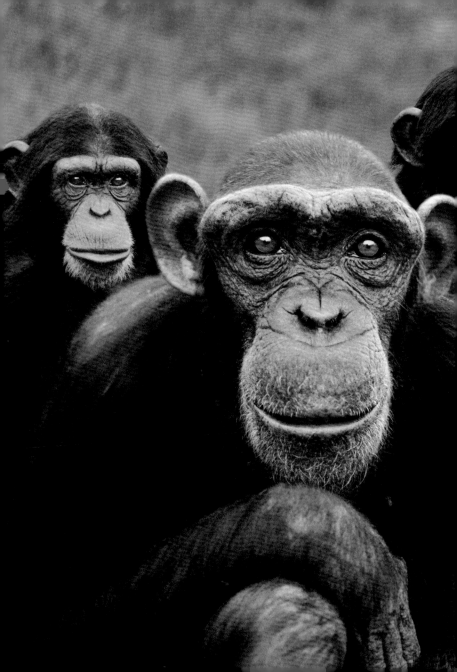

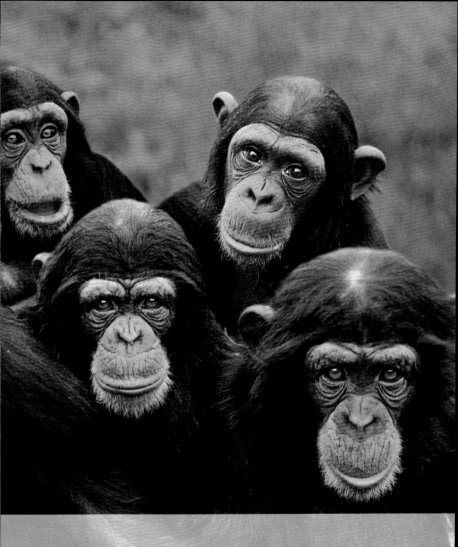

I believe that we choose our parents.

Louise Hay

Fifty years from now, it will not matter
what kind of car you drove, what kind of
house you lived in, how much you had
in your bank account, or what your clothes
looked like. But the world may be a
little better because you were important
in the life of a child.

Anonymous

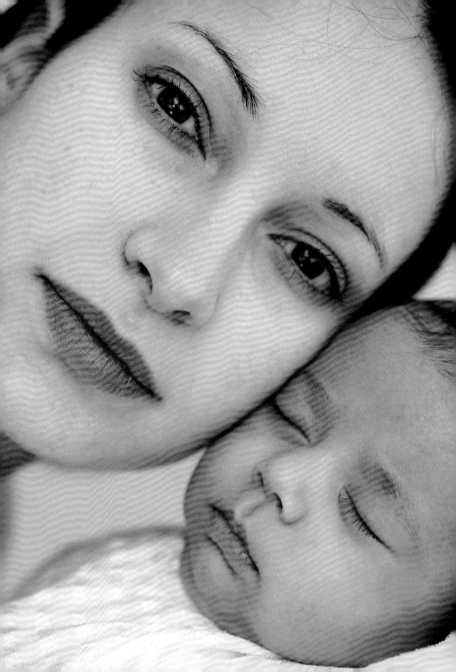

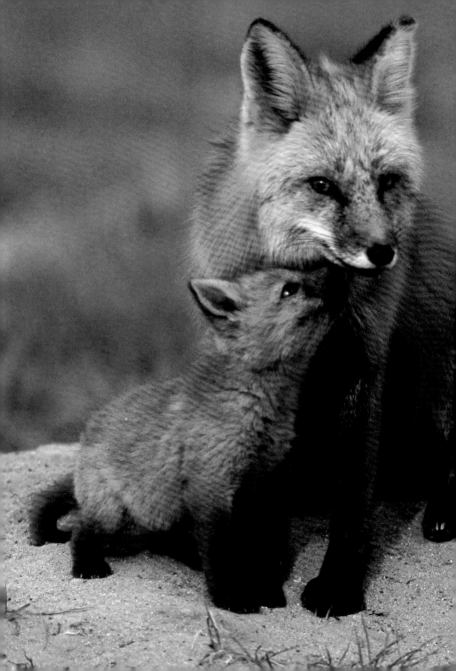

My life began with waking up and loving my mother's face.

George Eliot

Heaven is at the feet of mothers.

Arabic Proverb

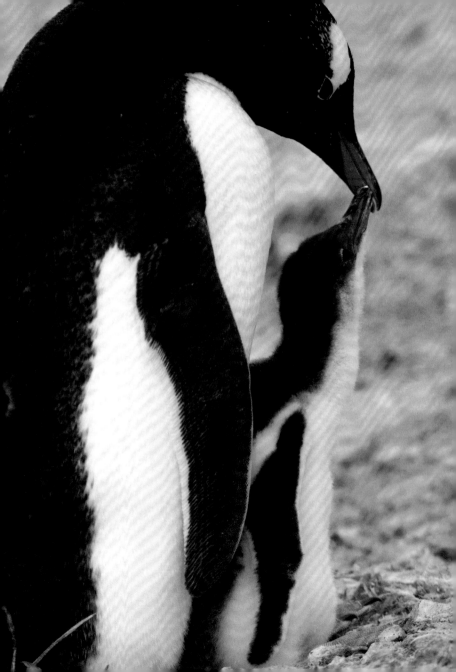

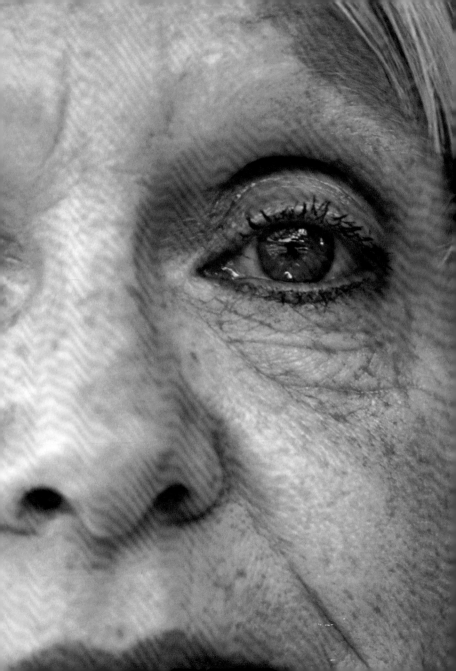

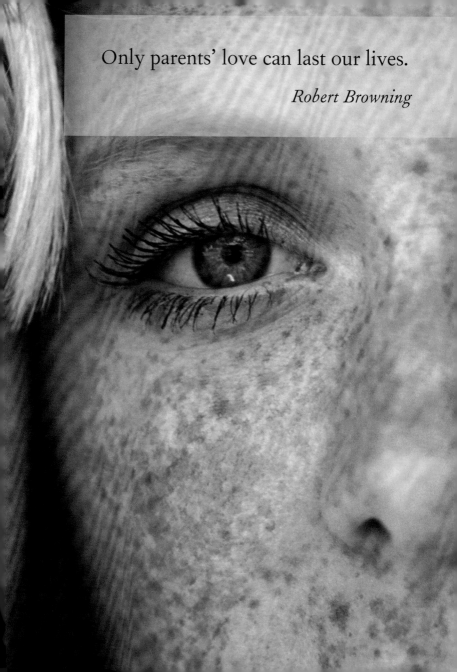

Only parents' love can last our lives.

Robert Browning

The more people have studied different methods of bringing up children the more they have come to the conclusion that what good mothers and fathers instinctively feel like doing for their babies is the best after all.

Benjamin Spock

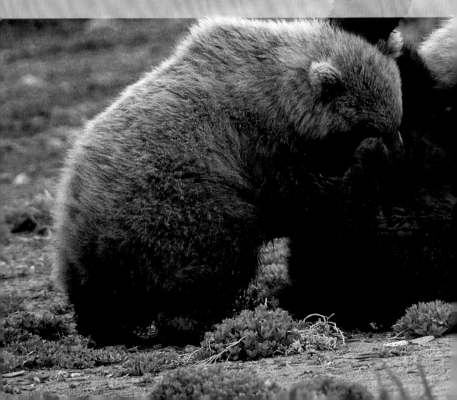

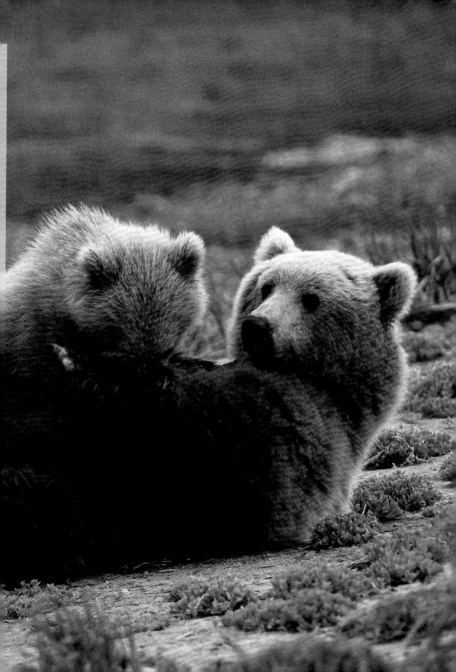

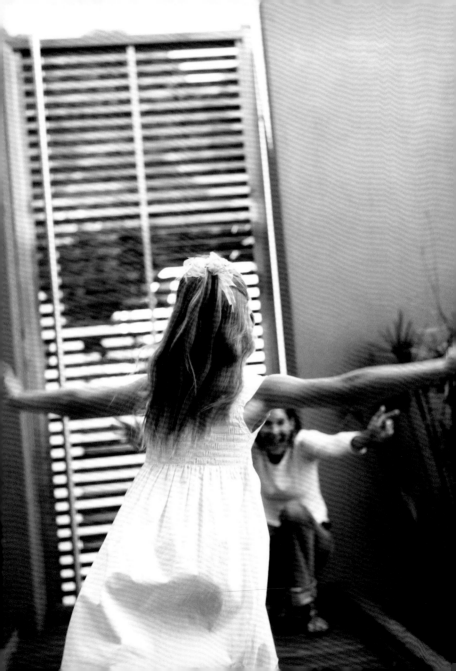

It will be gone before you know it. The fingerprints on the wall appear higher and higher. Then suddenly they disappear.

Dorothy Evslin

We have only this moment,
sparkling like a star in our hand . . .
and melting like a snowflake,
let us use it before it is too late.

Marie Beynon Ray

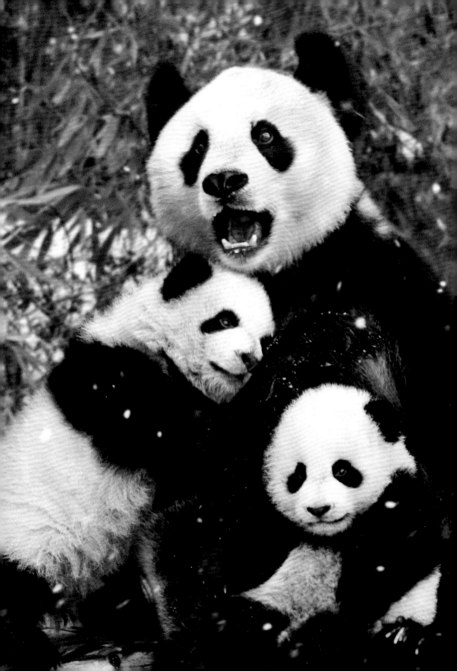

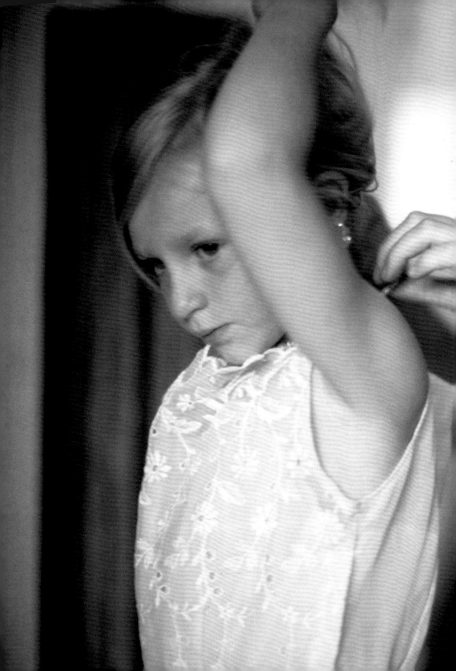

What do girls do who haven't any mothers
to help them through their troubles?

Louisa May Alcott

To describe my mother would be to write about a hurricane in its perfect power.

Maya Angelou

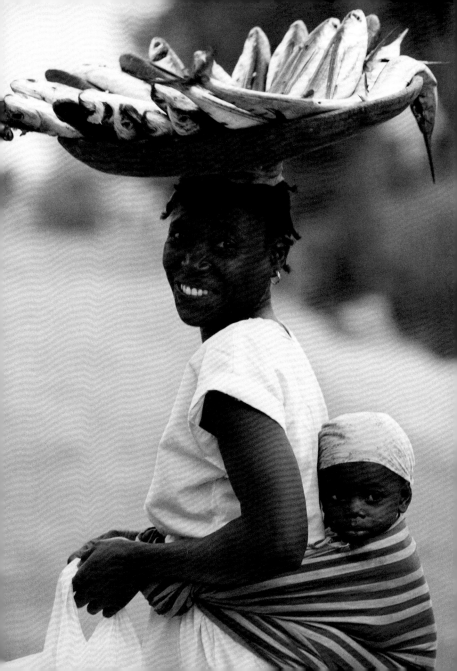

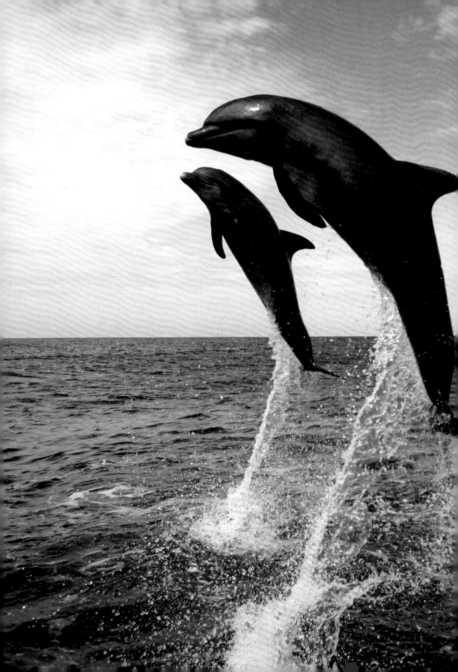

There is so much to teach,
and the time goes so fast.

Erma Bombeck

Mothers are the pivot on which the family spins.
Mothers are the pivot on which the world spins.

Pam Brown

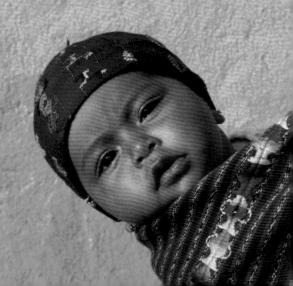

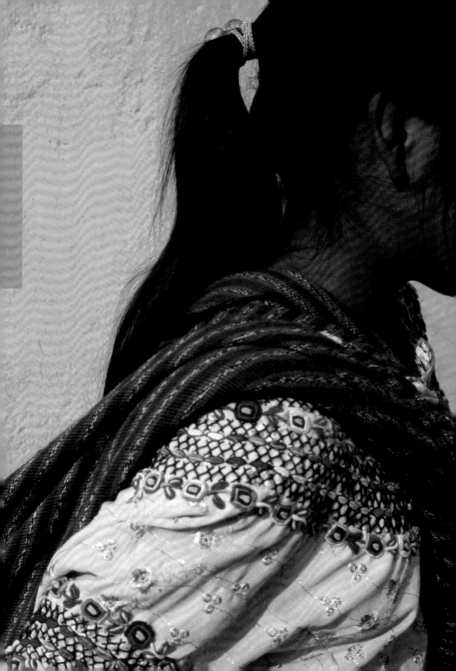

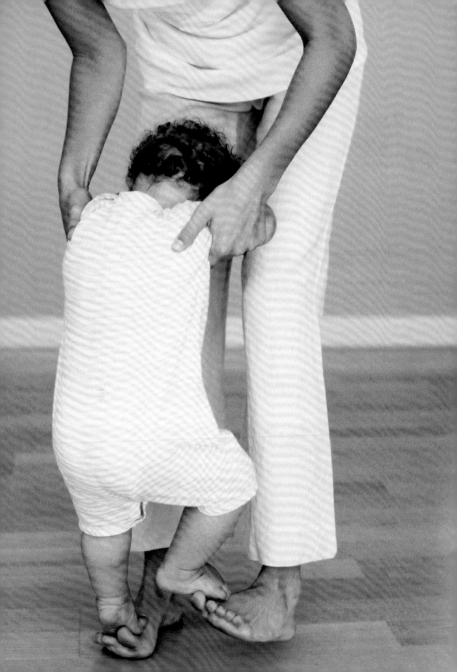

Making the decision to have a child—
it's momentous. It is to decide forever
to have your heart go walking around
outside your body.

Elizabeth Stone

Biology is the least of what
makes someone a mother.

Oprah Winfrey

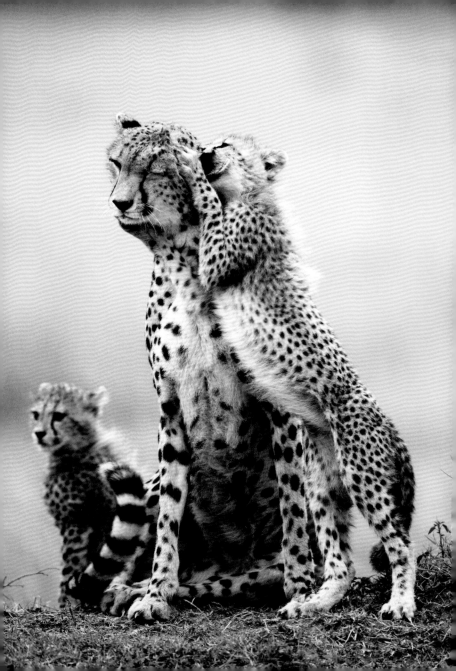

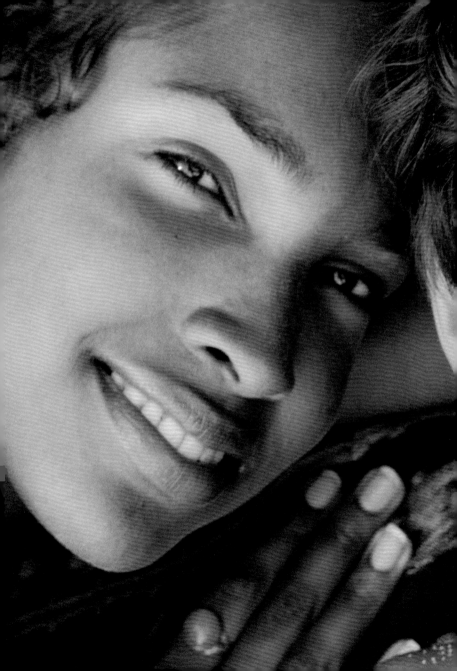

Is my mother my friend? I would have to say, first of all she is my Mother, with a capital "M"; she's something sacred to me. I love her dearly. Yes, she is also a good friend, someone I can talk openly with if I want to.

Sophia Loren

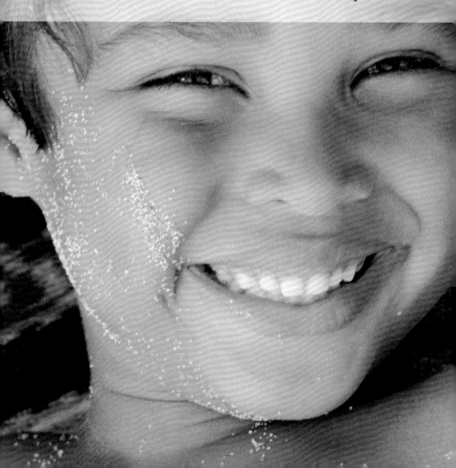

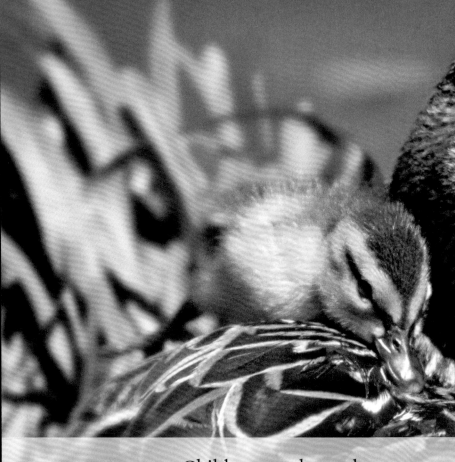

Children are the anchors
that hold a mother to life.

Sophocles

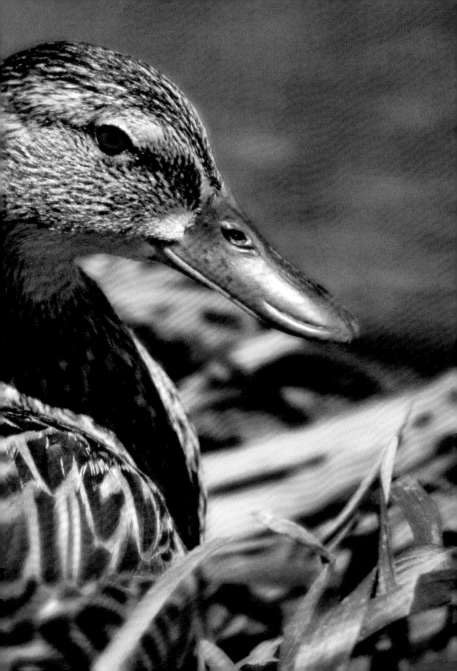

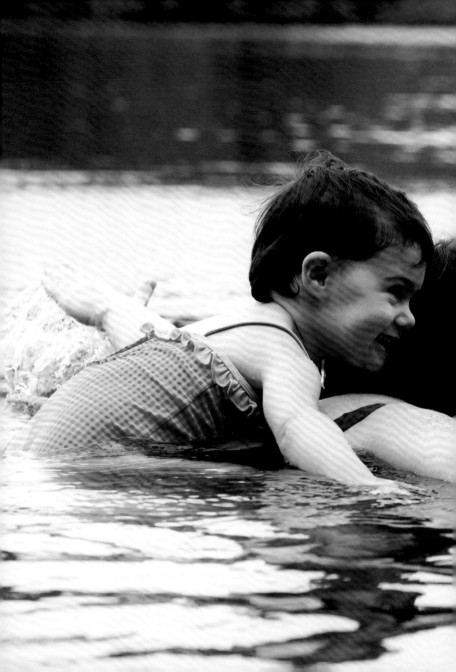

And so our mothers and grandmothers have,
more often than not anonymously, handed
on the creative spark, the seed of the flower
they themselves never hoped to see—or like
a sealed letter they could not plainly read.

Alice Walker

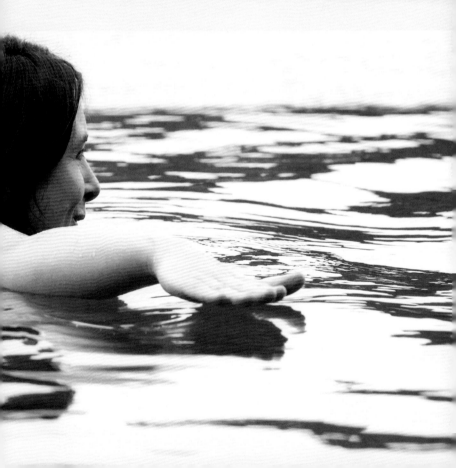

My mother had a great deal of trouble with me,
but I think she enjoyed it.

Mark Twain

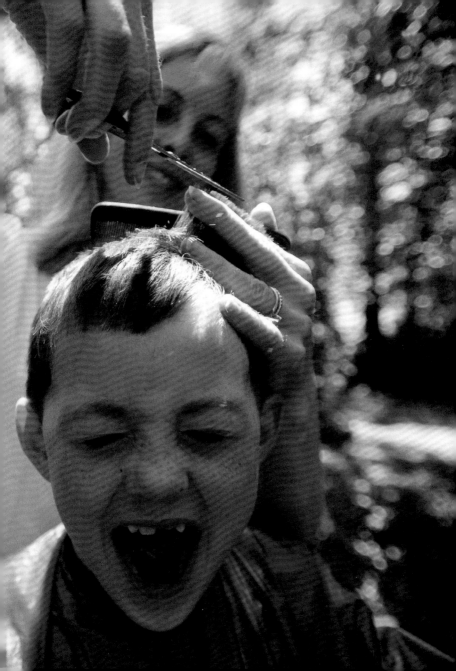

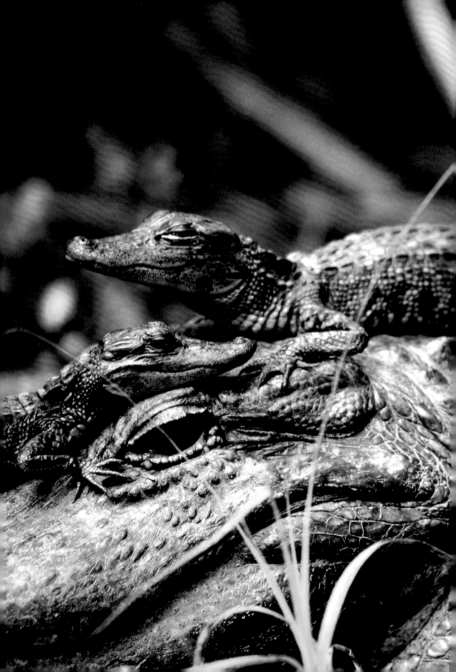

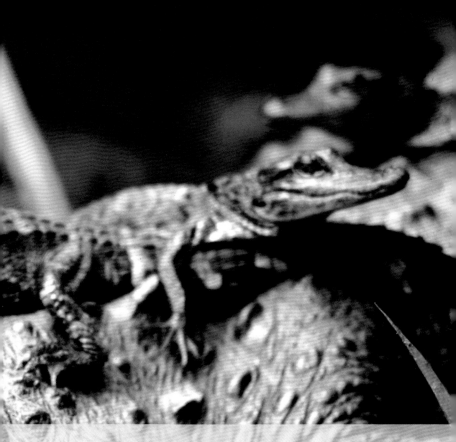

Oh, what a power is motherhood,
possessing a potent spell.
All women alike
fight fiercely for a child.

Euripides

Being a mother has made my life complete.

Darcy Bussell

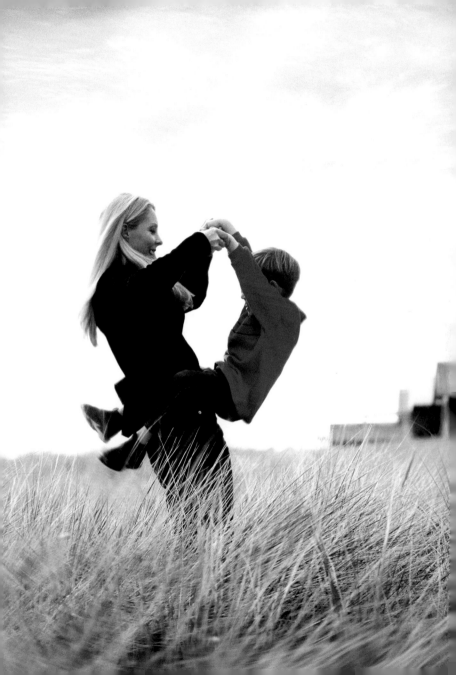

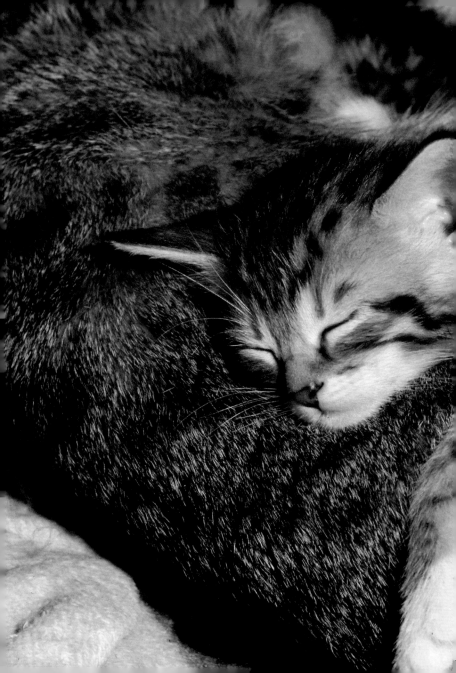

Motherhood: all love begins and ends here.

Robert Browning

My mother was the making of me. She was
so true and so sure of me, I felt that I had
someone to live for—someone I must not
disappoint. The memory of my mother will
always be a blessing to me.

Thomas Edison

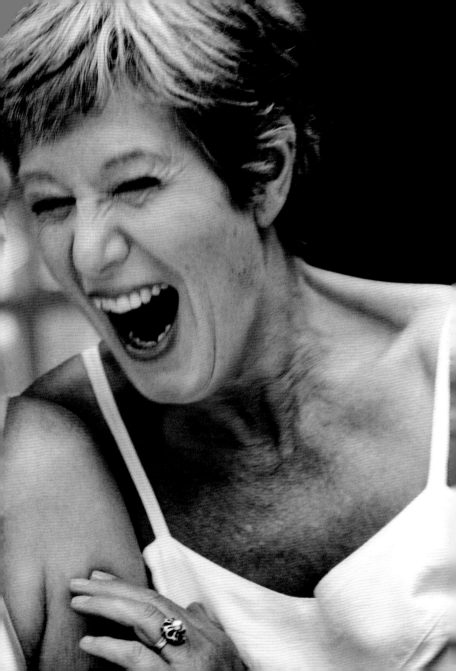

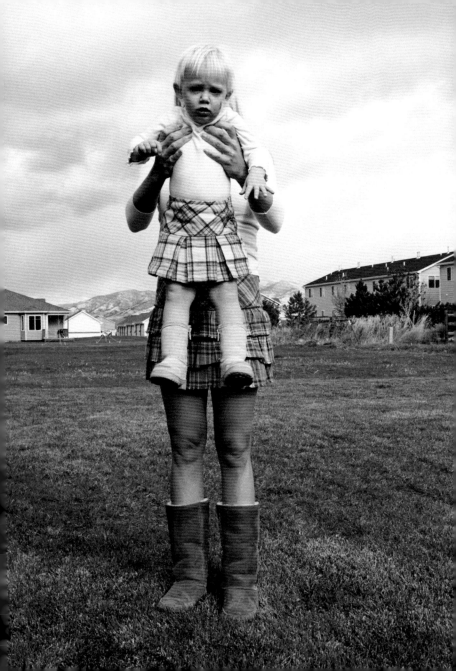

Mother knows best.

Edna Ferber

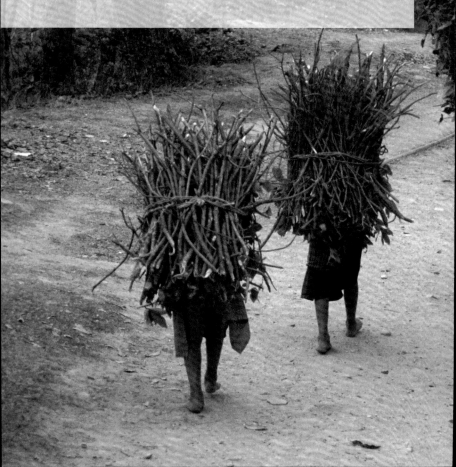

It is not what you do for your children but what you have taught them to do for themselves that will make them successful human beings.

Ann Landers

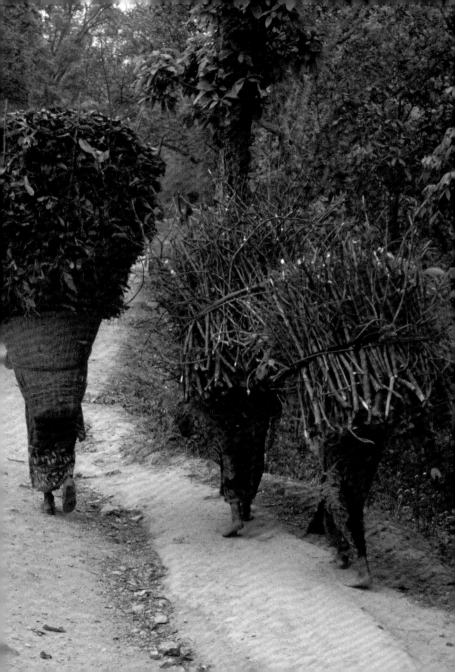

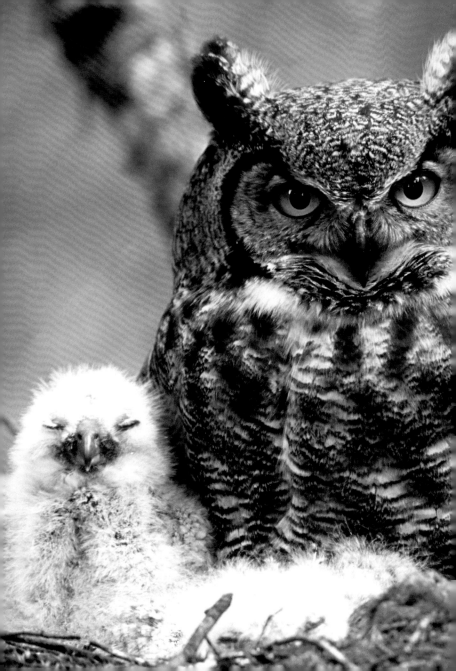

The best way to keep children home is to make the home atmosphere pleasant— and let the air out of the tires.

Dorothy Parker

Mother's Day is in honor of the best Mother who ever lived—the Mother of your heart.

Anna Jarvis

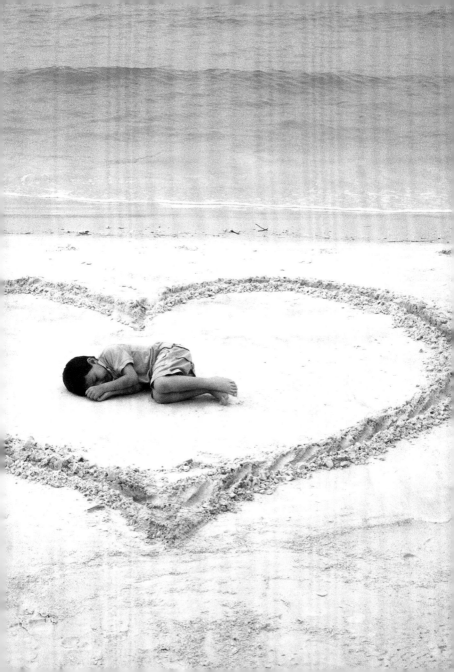

STERLING and the distinctive Sterling logo are registered trademarks of Sterling Publishing Co., Inc.

Library of Congress Cataloging-in-Publication Data Available

10 9 8 7 6 5 4 3 2 1

JL HOLLAN

Produced by Hollan Publishing, Inc.
100 Cummings Center, Suite 125G
Beverly, MA 01915
© 2008 by Hollan Publishing, Inc.

Published by Sterling Publishing Co., Inc.
387 Park Avenue South, New York, NY 10016

Distributed in Canada by Sterling Publishing
c/o Canadian Manda Group, 165 Dufferin Street
Toronto, Ontario, Canada M6K 3H6
Distributed in the United Kingdom
by GMC Distribution Services
Castle Place, 166 High Street, Lewes, East Sussex,
England BN7 1XU
Distributed in Australia by Capricorn Link (Australia) Pty. Ltd.
P.O. Box 704, Windsor, NSW 2756, Australia

Printed in China
Sterling ISBN-13: 978-1-4027-4914-8
ISBN-10: 1-4027-4914-7

For information about custom editions, special sales,
premium and corporate purchases, please contact
Sterling Special Sales Department at 800-805-5489 or
specialsales@sterlingpublishing.com.

Cover and series design by woolypear

ii–iii: Gozo/Workbook Stock, iv: Kazuyoshi Nomachi/
Corbis, 3: Ivo von Renner/Photonica/Getty Images,
4: Martin Puddy/Stone/Getty Images, 6: Steve Bloom/
Workbook Stock/Jupiter Images, 9: Karan Kapoor/Stone/
Getty Images, 10–11: Visual Language Library/Workbook
Stock/Jupiter Images, 12: Kristen Dacey Iwai/Workbook
Stock/Jupiter Images, 15: Steve Bloom/Workbook Stock/
Jupiter Images, 16–17: Plant/Workbook Stock/Jupiter
Images, 19: Chad Ehlers/Stock Connection/Workbook
Stock, 20: Joyce Tenneson/Aperture Images, 22–23: David
W Breed/Oxford Scientific/Jupiter Images, 24–25: Susan
Barr/Workbook Stock/Jupiter Images, 27: Jupiter Images,
28: Jupiter Images, 30–31: Peter Zander/Workbook Stock/
Jupiter Images, 32–33: Karan Kapoor/Stone/Getty Images,
35: Lilly Dong/Botanica/Jupiter Images, 36: Steve Bloom/
Workbook Stock/Jupiter Images, 39: David P. Hall/Corb
40–41: Steve Bloom/Workbook Stock/Jupiter Images,
43: Rick Gomez/Corbis, 44–45: Shattil and Rozinski We
and Bob/Oxford Scientific/Jupiter Images, 47: Martin
Harvey/Gallo Images/Getty Images, 48–49: F. Villaflor
Workbook Stock/Jupiter Images, 50–51: Matthias Breiter
Anzenberger Agency/Jupiter Images, 52: Jupiter Images
55: Steve Bloom/Workbook Stock/Jupiter Images,
56–57: Gustavo Di Mario/Stone+/Getty Images,
59: James L. Stanfield/National Geographic/Getty Image
60–61: Brakefield Photo/Brand X/Corbis, 62–63: Frans
Lemmens/Stone/Getty Images, 64: Jupiter Images, 67: W.
Wisniewski/zefa/Corbis, 68-69: Val Loh/Nonstock/
Jupiter Images, 70–71: Roy Gumpel/Stone/Getty Images,
72–73: Workbook Stock/Jupiter Images, 74–75: Joel
Sartore/National Geographic/Getty Images, 76–77: James
H Robinson/Oxford Scientific/Jupiter Images, 79: Colin
Anderson/Brand X/Jupiter Images, 80–81: Raymond
Blythe/Oxford Scientific/Jupiter Images, 82–83: Benelux/
zefa/Corbis, 84: Alexa Miller/Workbook Stock/Jupiter
Images, 86–87: Liba Taylor/Robert Harding World
Imagery/Getty Images, 88–89: Daniel Cox/Oxford
Scientific/Jupiter Images, 90–91: Matthieu Spohn/
PhotoAlto/Jupiter Images